For Alice, Merr and Mac

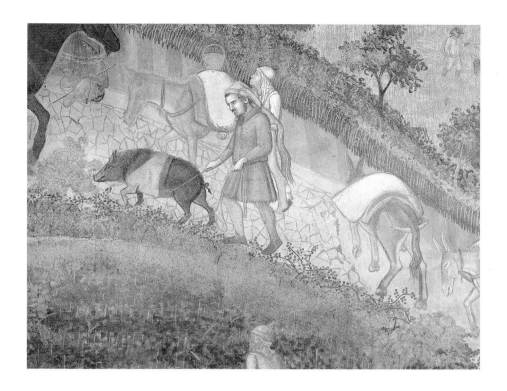

The Effects of Good Government in the City and Countryside,
a famous 14th-century fresco by Ambrogio Lorenzetti, includes a pig
going to the market. It is a black pig with a white band around its middle,
of the breed known as Cinta Senese (*cheen*-ta sehn-*eh*-seh).

Cinta comes from the Italian word *cintura*, 'belt'; Senese means of Siena.
Long ago, Cinta Senese pigs were common in Tuscany.
Today they are being brought back. You might see a herd of them
grazing on a hillside or foraging in the woods.

Lorenzetti painted the fresco across an entire wall in Siena's
Palazzo Pubblico (Town Hall). You can see it there. On the other hand,
in this book you can enjoy the artist's delightful scenes of Tuscan life
—from a pig's point of view.

I am abundantly grateful for the help given to this book by Louise Ames, Cesare Chini, Malcolm Howard, Helen and Peter Neumeyer, Alice Proctor, Jenna and Merr Shearn, Tyra Segers and, above all, Richard Mello. I treasure the sense of humor and support lent by Mario Curia, Monica Fintoni and Andrea Paoletti who, as publishers in Florence, have guided Cinta and me through this journey. [N.S.H.]

Mandragora s.r.l.
Piazza del Duomo 9, 50122 Firenze
www.mandragora.it

Edited, designed and typeset by
Monica Fintoni, Andrea Paoletti, Paola Vannucchi

Photographs
Studio Lensini, Siena

Printed in Italy by Alpilito, Florence

ISBN 978-88-7461-094-5

Nancy Shroyer Howard

Mischief in Tuscany

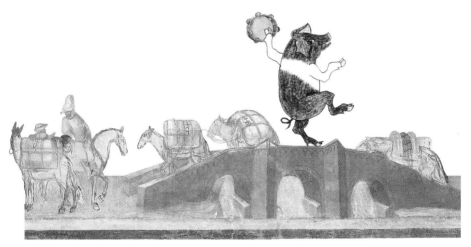

RUNNING WILD IN A FAMOUS ITALIAN PAINTING

Mandragora

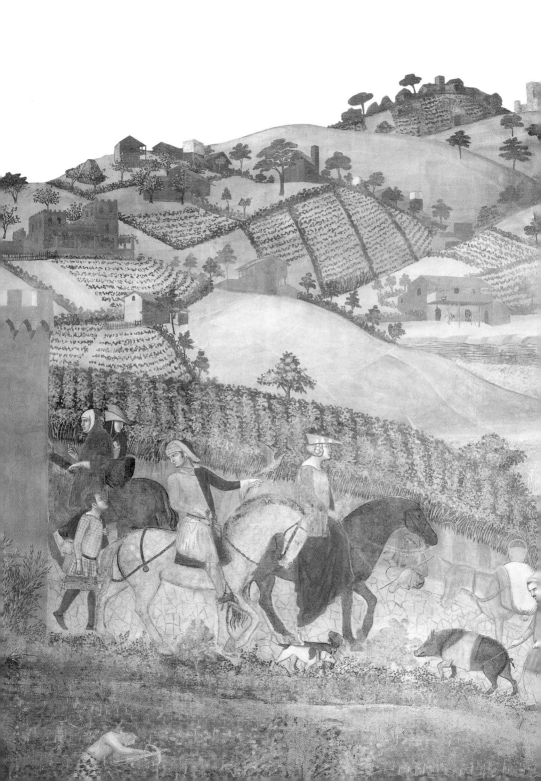

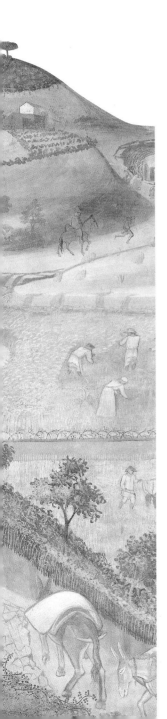

This is a story about me.
I appear in a fabulous and famous
painting in Italy.

You can find me here, in this small
part of the huge painting.

I am a Cinta Senese pig, a pig
of Siena. You can call me Cinta
(*cheen*-ta). Cinta comes from the
Italian word for 'belt'. I am proud
of the white belt around my belly.

This famous painting is about 650
years old, but I always feel young
—as you will see in this fantasy
about me, Cinta.

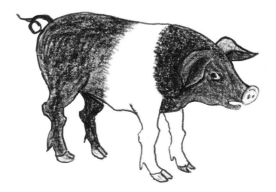

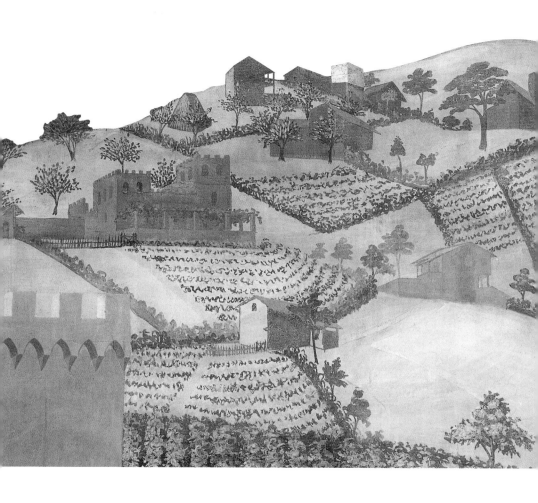

On a far hill, the morning began quite well for Cinta.
He filled his splendid black body with fourteen
bruised apples, twenty-six soft figs, ten sprouted potatoes,
and the sweet seeds of two pomegranates.

Cinta's fine white belt stretched tightly around his belly.
His black tail wiggled with contentment.

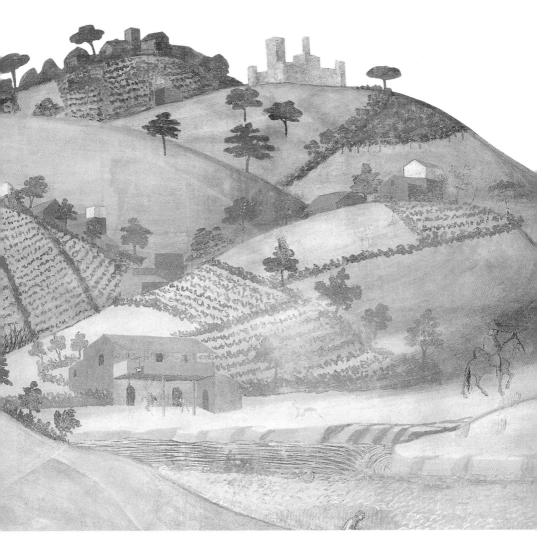

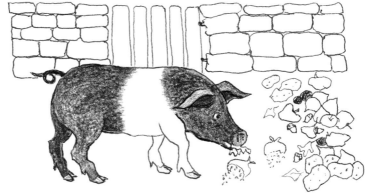

Cinta was thinking about a little nap
when he heard someone coming.

His master announced, "Today, Cinta, we are going
to the city! You are just right for the market."

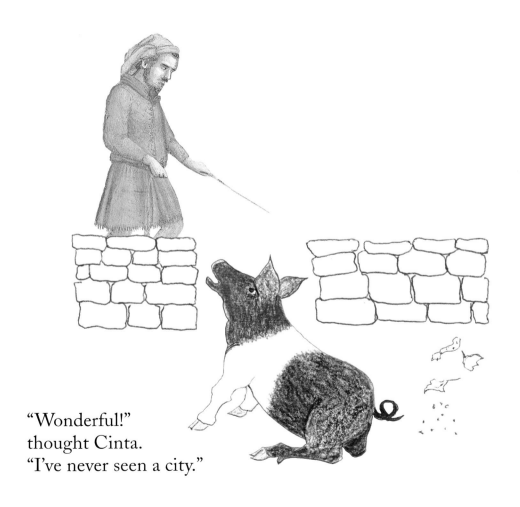

"Wonderful!"
thought Cinta.
"I've never seen a city."

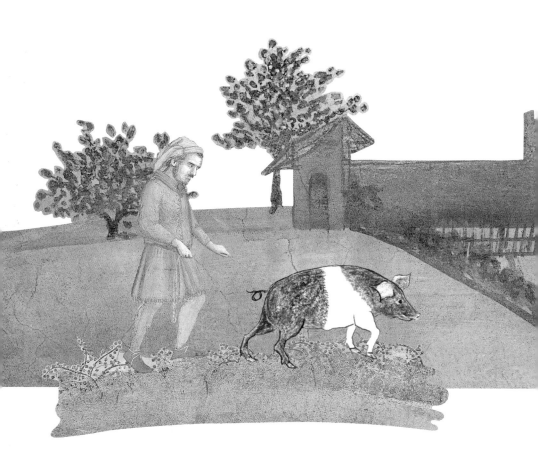

Off trotted Cinta with no prodding from his master's switch.
There was so much to see!

They walked through the grapevines of a great castle.
Grapes were ripe and juicy. Cinta longed to nibble a few.
He stopped, rolled over, and pretended he was having a feast.

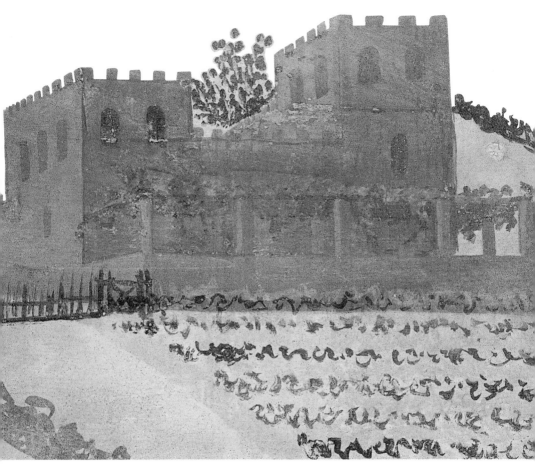

His master
switched Cinta's belly
and growled,
"Behave yourself!"

He fastened a chain
around Cinta's back leg.

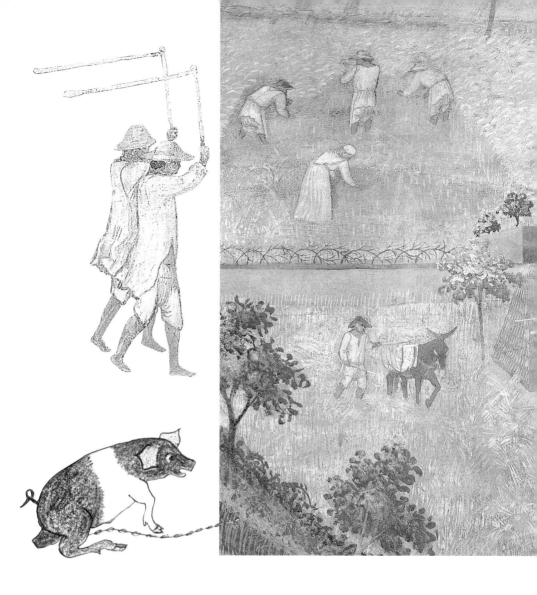

Cinta and his master came to a golden field.
Farmers bent to cut grain. Other farmers beat the grain
that was cut. Kernels of wheat flew off.

Cinta bent to eat a few, but his master switched
his bottom. Cinta whimpered and they tramped on.

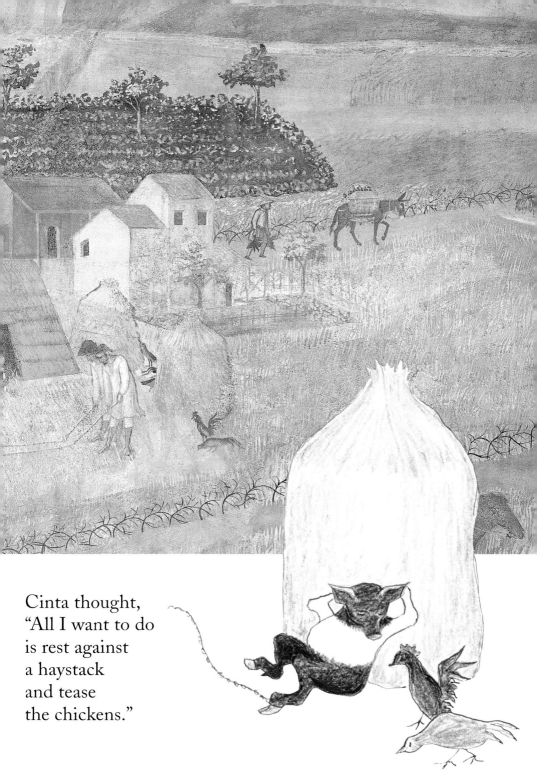

Cinta thought,
"All I want to do
is rest against
a haystack
and tease
the chickens."

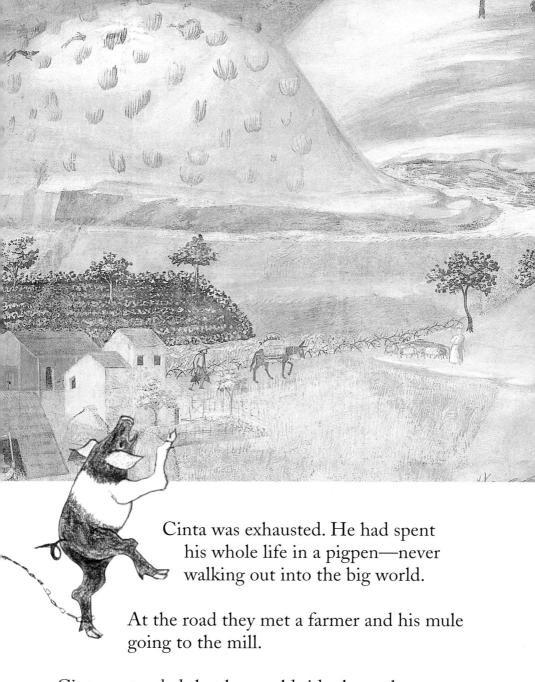

Cinta was exhausted. He had spent his whole life in a pigpen—never walking out into the big world.

At the road they met a farmer and his mule going to the mill.

Cinta pretended that he would ride the mule. He jumped up in the air and waved his hooves.

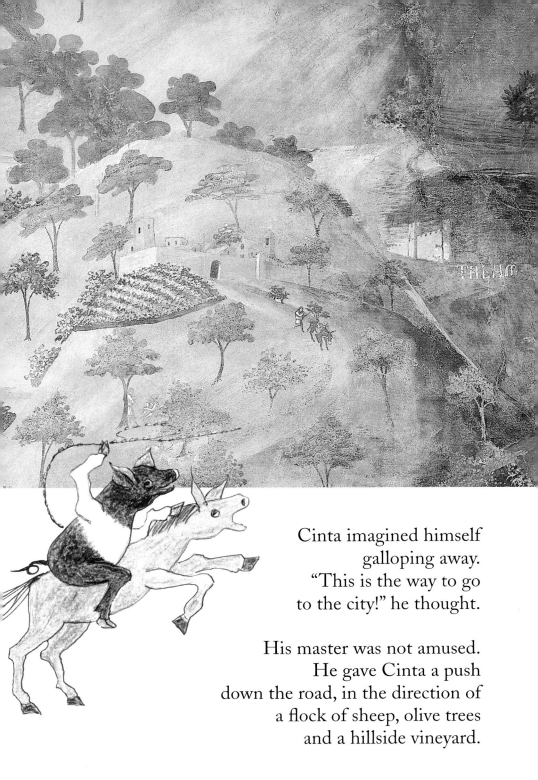

Cinta imagined himself
galloping away.
"This is the way to go
to the city!" he thought.

His master was not amused.
He gave Cinta a push
down the road, in the direction of
a flock of sheep, olive trees
and a hillside vineyard.

His master led Cinta downhill to the mill.
The river looked muddy but cool.

Cinta had a great idea.
"What I really want to do
is float to the city!"
Cinta lay down and
imagined himself
afloat.

His master snapped the chain. Cinta scrambled up.
They trudged along the river bank, passing two oxen
plowing a field. "I'd rather go to the city than plow"
snorted Cinta.

Soon Cinta was surprised to hear the bellowing of mules,
clatter of hooves, and shouting of merchants at a bridge.

Cinta was amazed. "This sounds quite interesting"
he decided.

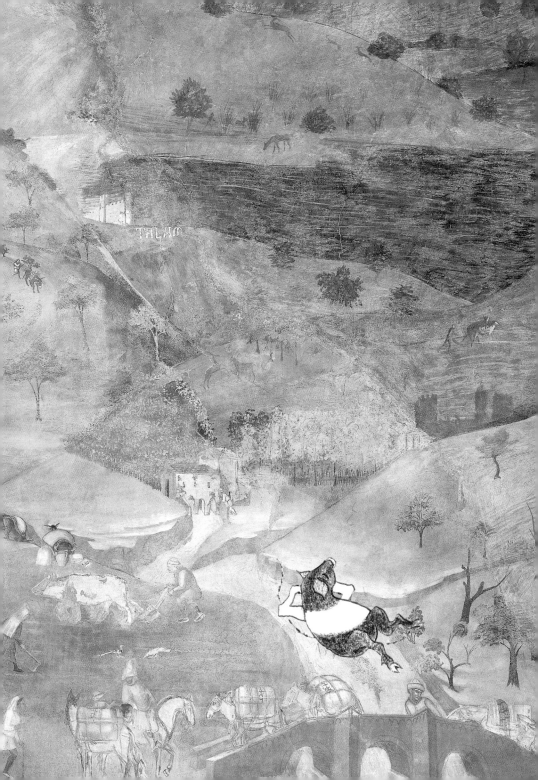

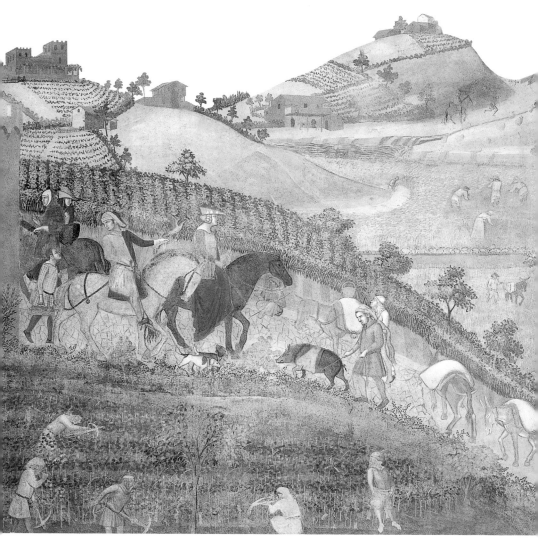

Cinta and his master
began the long climb to the city.
A hunting dog lowered his head
and snarled. Cinta blew a cloud
of dust at it and snorted,
"I'd rather go to the city than hunt!"
Then Cinta had a shock.

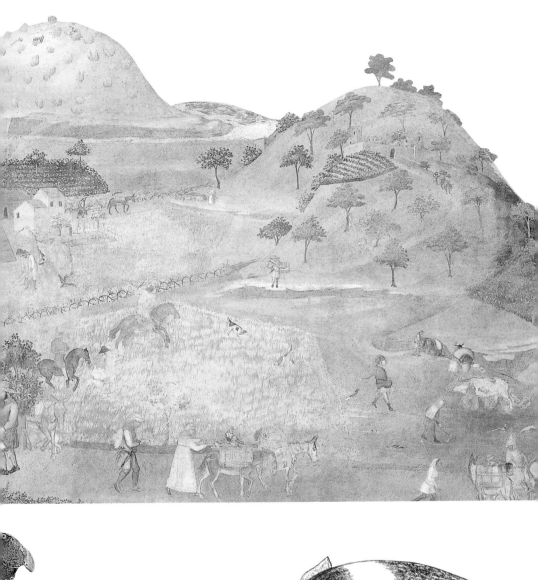

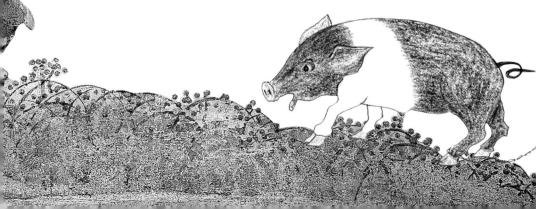

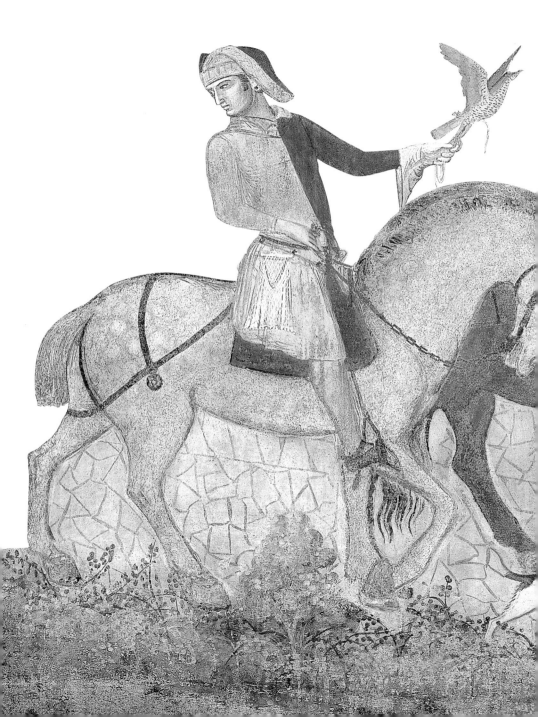

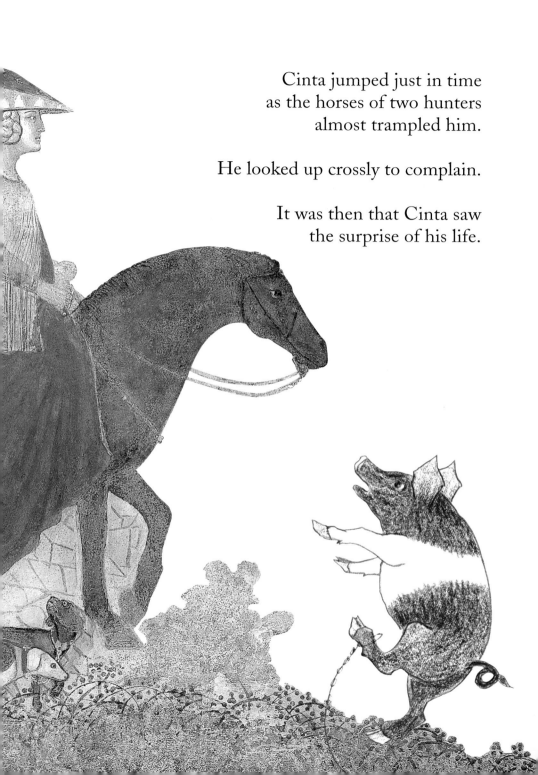

Cinta jumped just in time
as the horses of two hunters
almost trampled him.

He looked up crossly to complain.

It was then that Cinta saw
the surprise of his life.

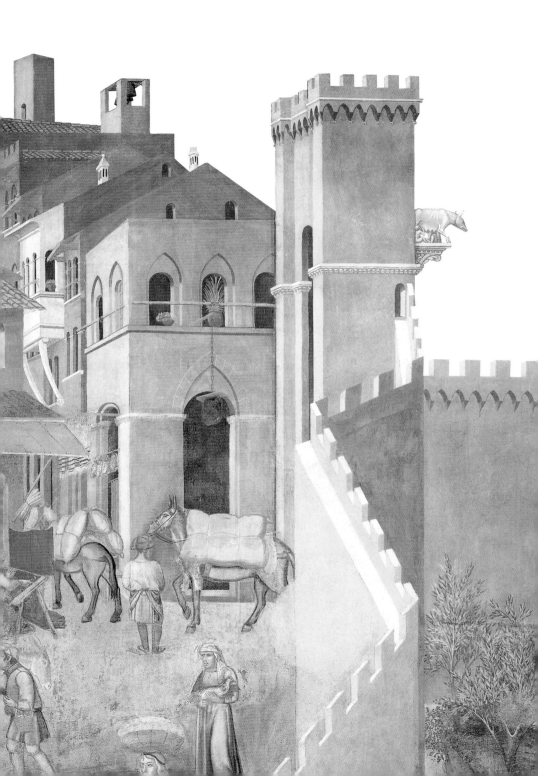

The city!

Great brick walls!

A tall tower!

A gate!

Cinta gave an enormous squeal. "Eeeeeeeeeeeeeeeeeeeee!"
A hunter's falcon flew off.
A rider looked back in alarm.
The nun prayed that it wasn't
the end of the world.

The doors of the gate stood open.
Cinta leapt for joy. He yanked his foot free
from the chain and bolted toward the gate.
 He squealed again.

"It must be
stupendous inside!"

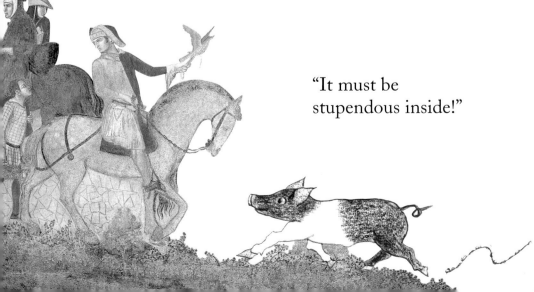

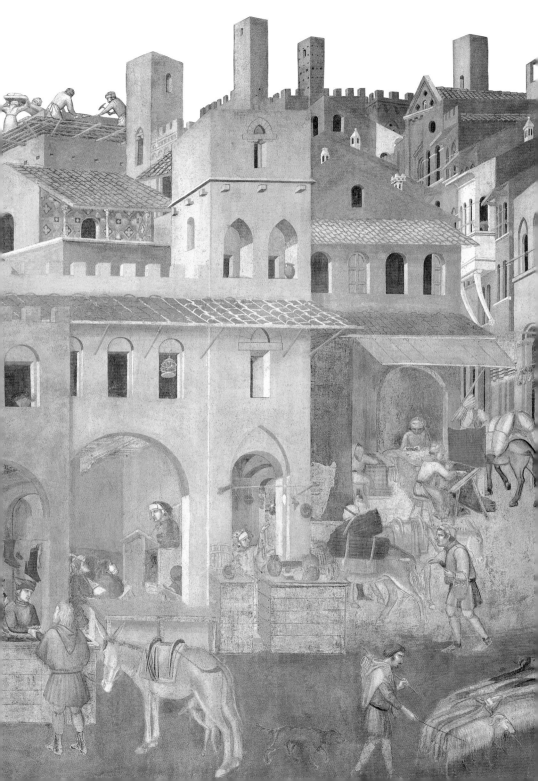

Without stopping, Cinta crashed
into a weaver and sent the cloth flying.

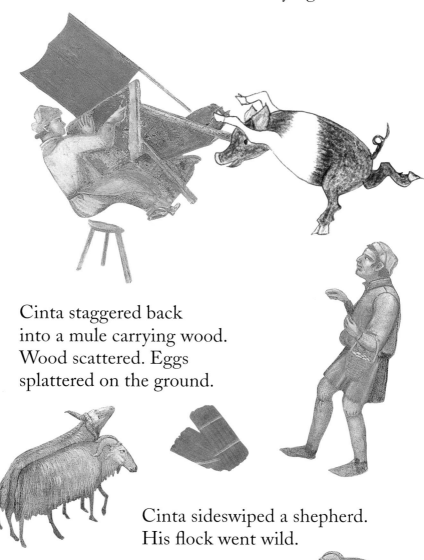

Cinta staggered back
into a mule carrying wood.
Wood scattered. Eggs
splattered on the ground.

Cinta sideswiped a shepherd.
His flock went wild.

Cinta exclaimed to himself,
"What a good beginning!"

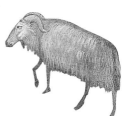

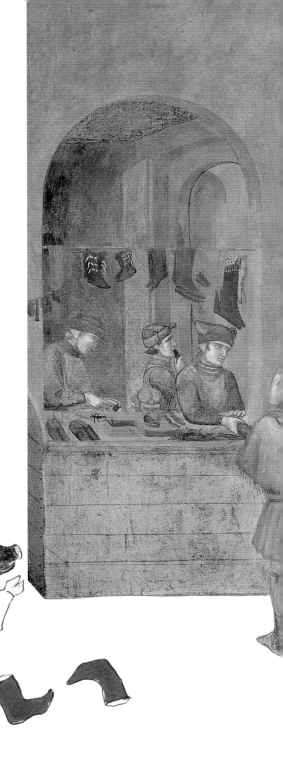

Cinta bashed into
a cobblers' shop. Shoes
and boots sailed away.

Cinta squealed
with excitement.
He tried on the red boots
and they felt fine.

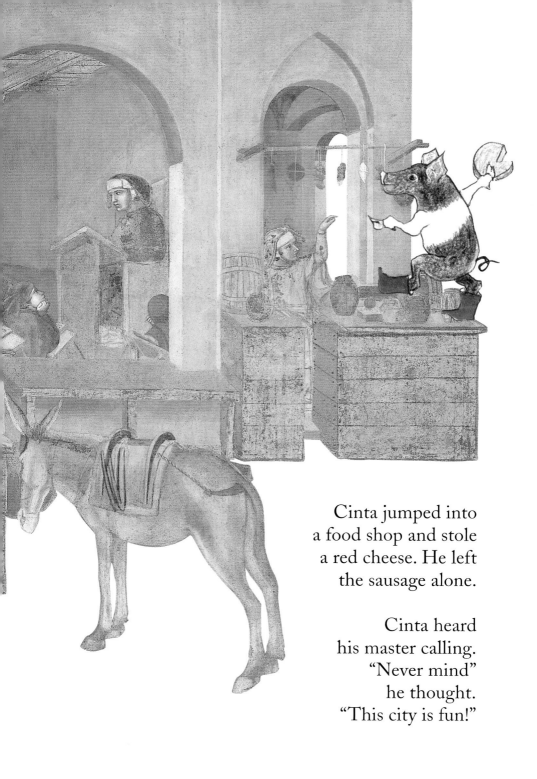

Cinta jumped into
a food shop and stole
a red cheese. He left
the sausage alone.

Cinta heard
his master calling.
"Never mind"
he thought.
"This city is fun!"

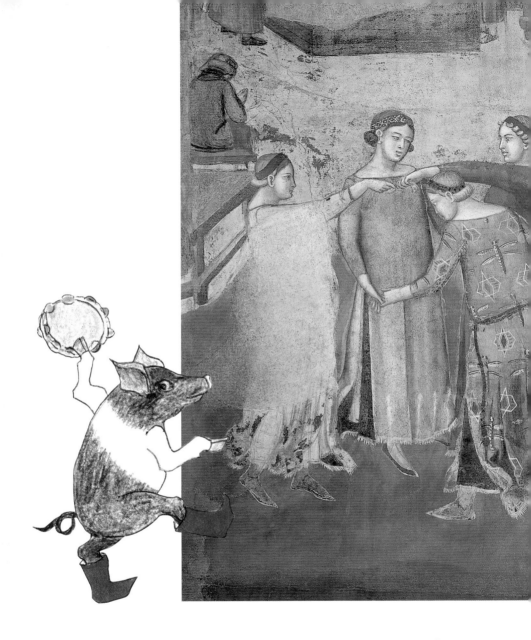

Cinta saw girls dancing in the street. He snatched
their tambourine and shook it hard. He hopped and
twirled among the girls. He kicked up his heels.
"I didn't know I was such a fine dancer!"

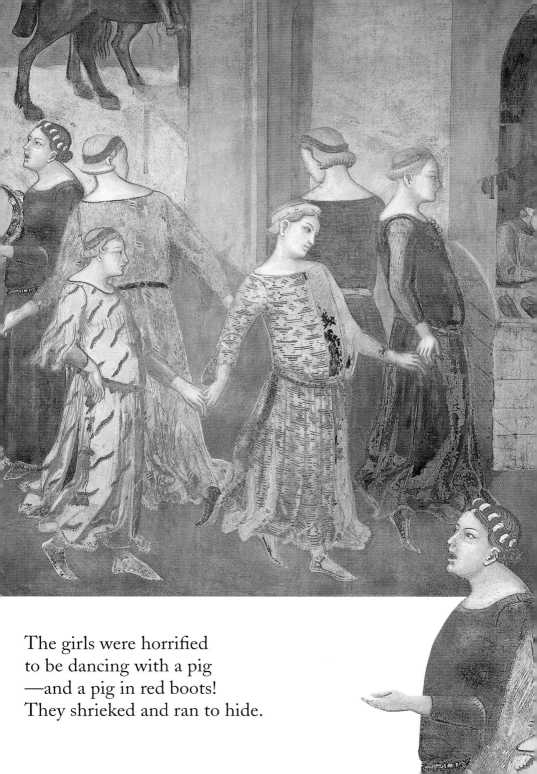

The girls were horrified
to be dancing with a pig
—and a pig in red boots!
They shrieked and ran to hide.

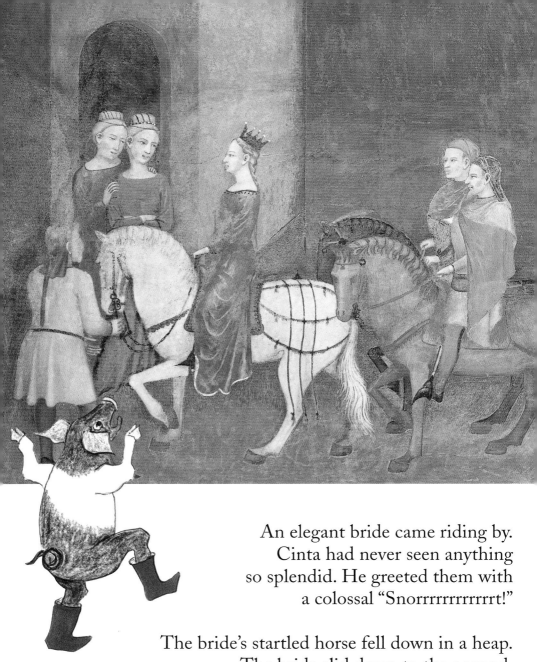

An elegant bride came riding by.
Cinta had never seen anything
so splendid. He greeted them with
a colossal "Snorrrrrrrrrrrrt!"

The bride's startled horse fell down in a heap.
The bride slid down to the ground.
Her jeweled crown tumbled away.
The wedding was quickly postponed.

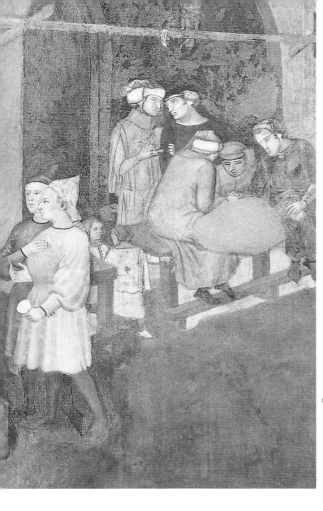

Two girls
exclaimed,
"What a
horrible hog!"

Game players
whispered,
"This has to stop!"

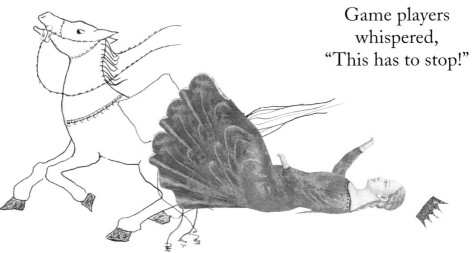

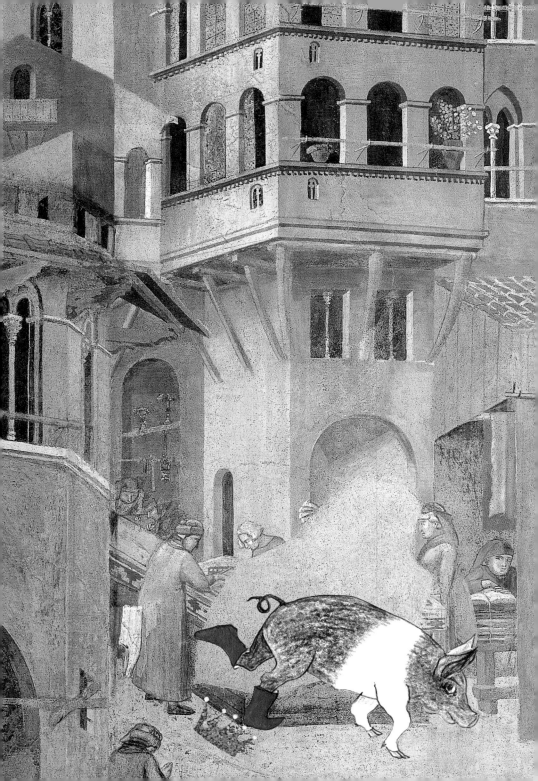

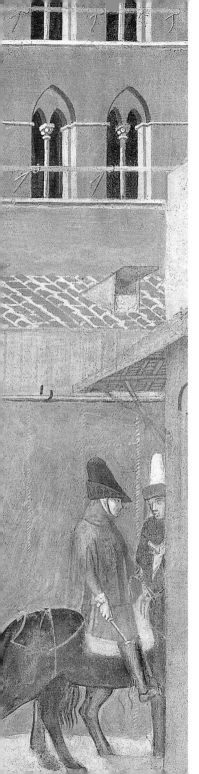

Cinta stumbled over the crown
and kicked up a small dust storm.
Shoppers howled.

An angry bookkeeper cursed
in very bad words.

Two gentlemen agreed,
"We will find
that pig's master."

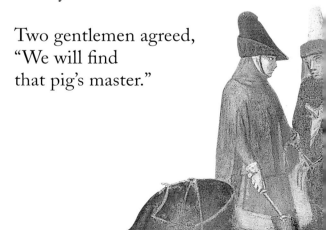

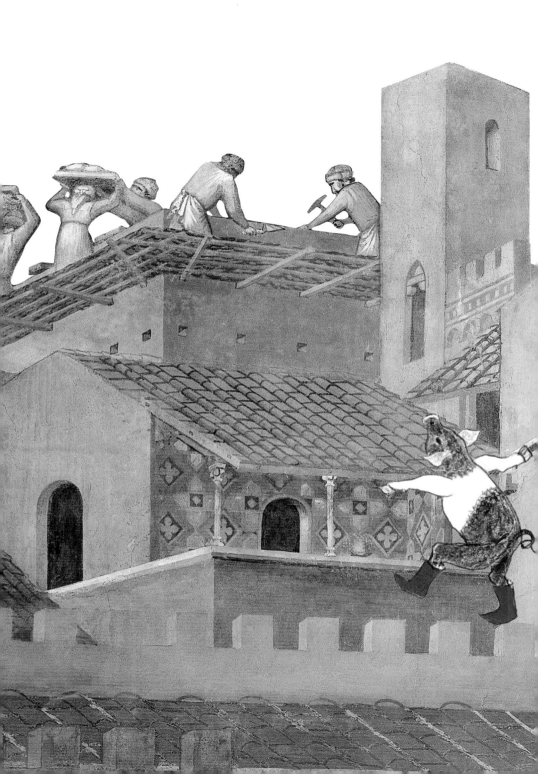

On a palace above, a bricklayer bent to see the chaos
below. His bricks tumbled down into the street
and just missed the pig.

"What a thrill!" Cinta grunted, and
looked up. There he saw a beautiful
porch. "A lovely place to rest"
he decided and began
scrambling to the rooftop.

Cinta was almost
at the porch when his master
roared from below.
"You impossible pig! You have
made terrible trouble.
The City will judge us.
You will be thrown in jail
and I will receive nothing for you at the market!"

Cinta jumped down and landed with a thud.
He began to worry. He shook in his boots.
His master yanked them off.

Cinta and his master appeared before the Virtues who guided the city.

Cinta knelt before JUSTICE who decided right from wrong. She said, "We must weigh the matter."

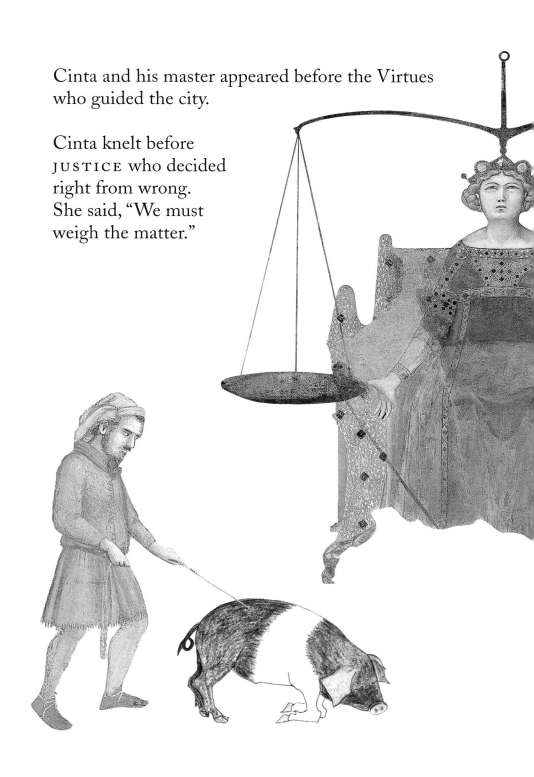

Cinta tried to look as pitiful as possible.
The old man who represented THE CITY proclaimed,
"I must form a committee."

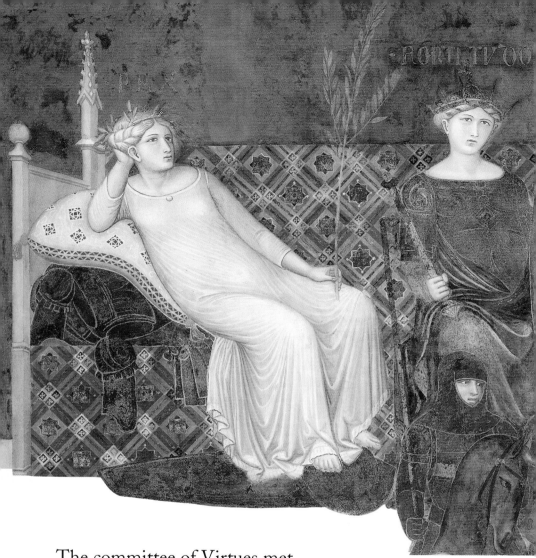

The committee of Virtues met.

PAX, known as PEACE, leaned back, crushing the armor of war, and complained, "There is no peace!"

FORTITUDE, the courageous, proclaimed, "We must be strong!" Her soldiers said, "Who, us?"

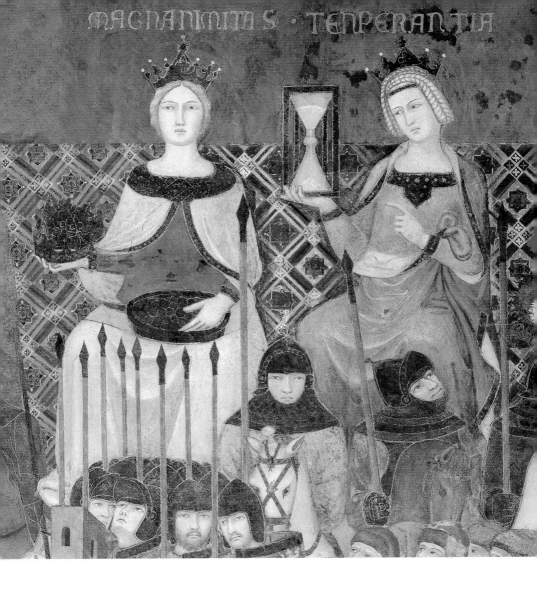

MAGNANIMITY, the generous, shook the coins
in her lap and suggested, "Let's buy him off."

TEMPERANCE, always moderate, sighed,
"We must not act rashly."
Cinta was terrified.

The Virtues arrived at their decisions.

FORTITUDE raised her shield. "This pig has spirit and courage. I salute him."

MAGNANIMITY sighed and tossed Cinta's master a handful of coins.

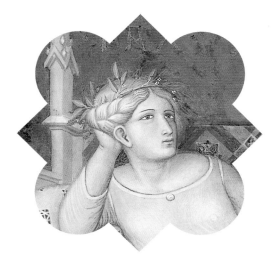

PAX leaned back on her pillow. "I will exchange my olive branch with this pig for a little peace and quiet."

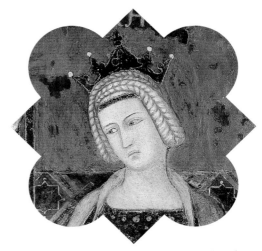

TEMPERANCE looked down at Cinta. "Because he so loves our city I forgive his mischief. But he should leave before creating more."

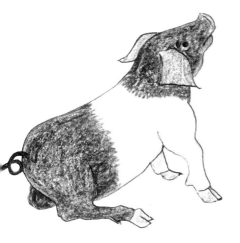

JUSTICE concluded, "On balance, this is fair."

THE CITY bellowed, "Leave at once and never come back!"

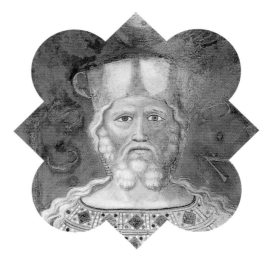

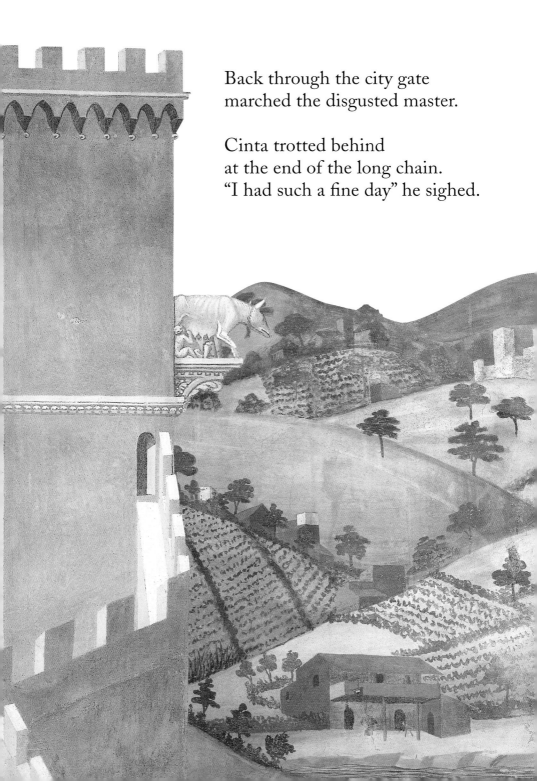

Back through the city gate
marched the disgusted master.

Cinta trotted behind
at the end of the long chain.
"I had such a fine day" he sighed.

Now it was dusk. Cinta could barely see the farmhouses, the grapes on their vines, the tall pine trees, or the castle on the hill.

His master locked Cinta in his pen with extra care, but Cinta had no thought of running back to the city. He decided that sometimes memories are the best of it.

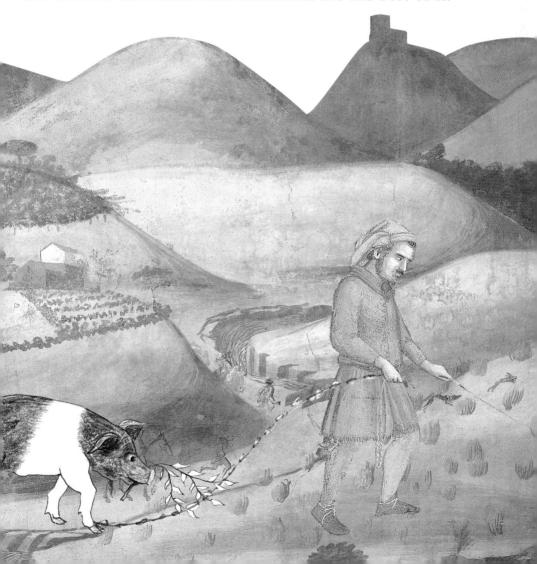

The next morning began fairly well for Cinta—under the circumstances. His master tossed him a basket of ten rotten tomatoes, two mouldy cabbages, and four wormy peaches. Cinta gobbled them up. When his master turned away, he ate the basket, too.

Cinta rolled onto his side and lay down on his olive branch. "Can I remember all of yesterday?" he wondered.

Cinta searched his memory and slowly, in his imagination, the whole scene unfolded before him:

the red brick castle
the farmers, the mule
the hills and the mill
the bridge
the city walls, the gate
the woodman, the eggs
the cobblers, the cheese
the dancers and the dust
the bride, her white horse
the bookkeeper
the bricklayers
the porch—and even
the bird in its cage.

"I think," grunted Cinta,
"they will always
be there."

▶ OPEN AND UNFOLD

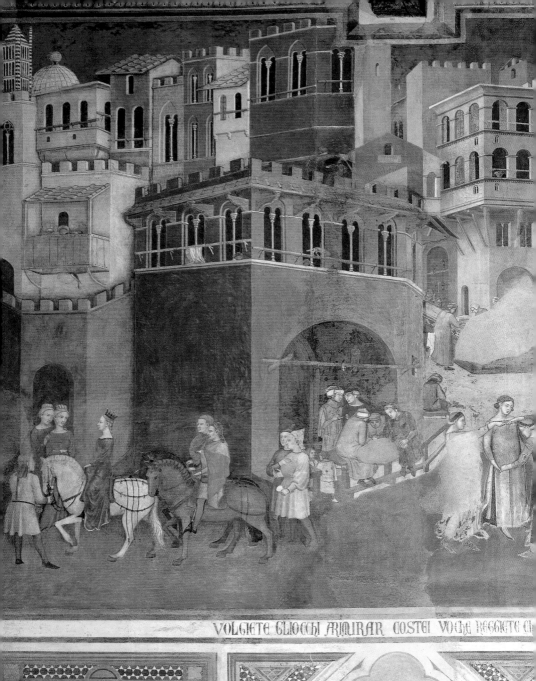

VOLGIETE GLIOCCHI ÆRIMIRAR COSTEI VOChE REGGIETE CI